In Me Own Words

* the autobiography of Bigfoot *

graham roumieu is a Toronto based author illustrator who is easily annoyed.

For information address Manic D Press, P.O. Box 410804, San Francisco, California 94141

~~Special~~ Thanks to production maestro Scott Idleman (Blink) Bill Grigsby (Reactor Art + Design). and Daphne Hart.

ISBN 0-916397-84-X
printed in china

In Me Own Words

* the autobiography of Bigfoot *

words and pictures by
graham roumieu

* Manic D Press *
San Francisco

I Am Not CHeWb

me think Chewbacca jerk.
He me can act. He ride
Bigfoot coat tails. He think
he cool, but he not. He phoney
loser with no class. He all
messed up on crack me think.
People think me chew bacca
Sometimes, No! Me have Job,
Bad Wookie. Bad.

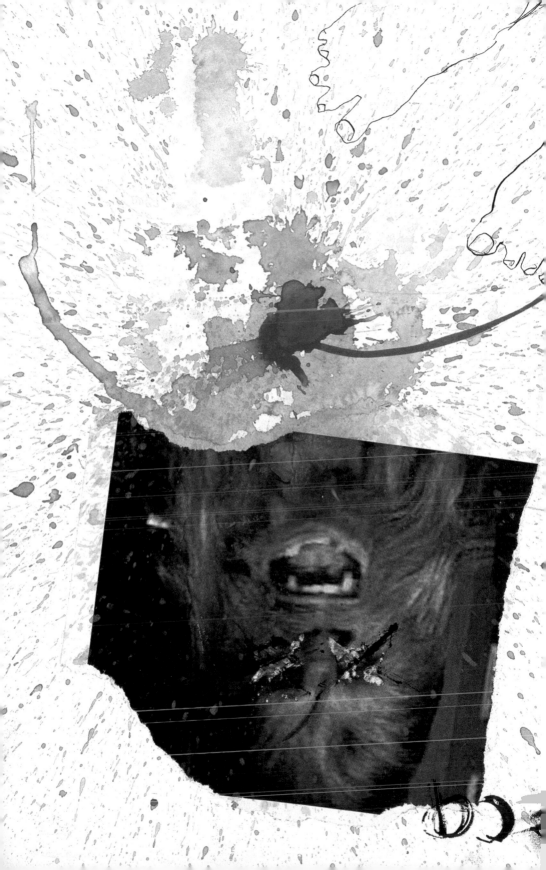

Me have opinion

What happen world me ask? Me once beli[e]
in good. Now, no. World go shit, just like
bigfoot screenwriting career. Me write story
once about bigfoot who hate life work for
corporation. He form club with other bigfoot and figh
in basement ~~many~~ clubs. It star me, Lou
Ferigno and Pat Morita. It called Tussel club.
Hollywood say I crazy. ~~Now~~ Pat Morita no return
calls. He snob. He no get christmas ~~card~~
Maybe I smash with log.

Anyhoo, movie never get make.
Lots of people make money from bigfoot.
You think me see one thin dime? No. Monster
truck people no even ask to use name. Teach them
lesson. Maybe I smash with log, maybe rock. I
see what tickle fancy when time come. Make
hurt good.

feelings

Riding bike

Tree is gone
So is bike
Bike chained to tree
So me steal truck
Back into you
While you ride me
 bike.
You could scream help
But me eat you face.

Stop, Smell Rose

Where you go
Man on road?
Why you run
 when me want talk?
You manners bad
 so me learn you good
Tear off legs
So no more run. ☺

LOVE IS SAD

Man on funny car
Me love!
Want for big foot wife
One day me catch
Try make baby
but you head collapse
like sock full of eggs
Me cry
Birds cry too
Me sad

than listen to squirrels playing
slide whistles all day. What I
wouldn't give to whack them with
badminton racquet. They shave bad
word in Bigfoot back fur. I mean
come on. Why they be trippin'
on Me?
Bigfoot gots to represent.

Home

Have it pretty tough as kid.. Other kids no want play. They say I too rough say I kill too much. Who make them judge and jury? Puberty hard for bigfoot. Start get curly fur in place where no curly before. Start mark territory and kill rival males. Hard make friend. No have date for senior prom. Susie Jenkins say she sick and ditch me for Bobby Jones. Me still write her letters and phone at 3 oclock in morning, then pretend wrong number.

Susie if you read me still take you back

Cold chillin with me homies.
Flyboyz 4-eva.

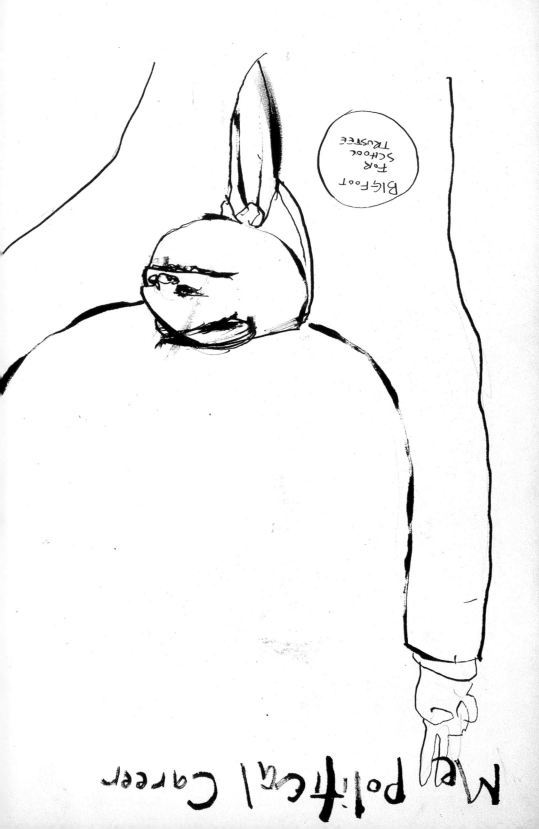

My Political Career

Me like man's hair. Me take
him hair and eat man.
pretty hair,
make famous.

↓ this picture ruin bigfoot

me and Koko

Me and Koko go way back. We meet at roulette table at Mirage in Vegas. Him book Koko's Kitty had been #1 on N.Y. Times Best seller list for 10 week. Me just go through messy divorce. Him not say much but we hit it off good. He talk with hands. He say once "Boot pancake Koko hate want tree Kitty now." Change me life. Him crazy too, have this thing for cats. Me never understand. We not talk much anymore. Me guess that just way it go sometime.

1985 PHOTO TAKEN IN NEW JERSEY AIRPORT LOUNGE 16
HOURS BEFORE KOKO THE GORILLA'S NEAR FATAL OVERDOSE.
BOTH BIGFOOT AND KOKO WOULD HAVE THEMSELVES
ADMITTED TO THE BETTY FORD CLINIC BY THE YEAR'S END.
MITSEY THE CAT (FAR RIGHT) COMMITTED SUICIDE AFTER
HEARING NEWS OF THE BREAK-UP OF WHAM(!).

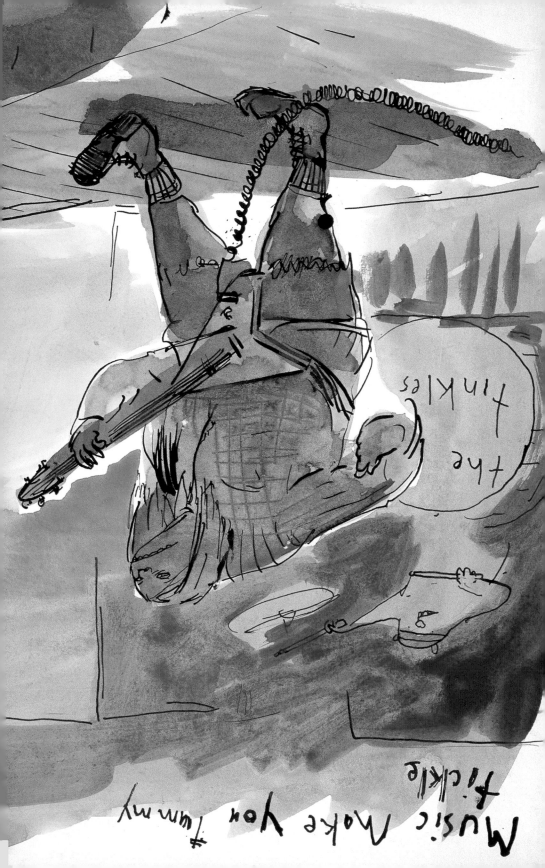

Back in late eighties I wake up say "What all about?" Later same day I quit job as junk bond trader, abandon wife and children, burn down dog and hitch ride to Seattle and start socially concious band Tinkles. We sing songs about "the man" and man related stuff. Deep.

Pretty soon creative well run dry. Whole sets just me asking "is there doctor in audience?" "this woman baby." Or "Watch you step." Finally all fall apart when Jeffy the drummer get clap from back stage betty. "Pee fire" he say "fire."

Me never go to Vietnam. Me too busy killing people in woods here. See Deer Hunter 15 times though. Sometimes. Me pretend Me 'Charlie' and go running through bushes with sticks tied to head, then jump out and kill. Nothing new for me really, make believe make more fun though.

N am

This me Halloween cos time last year.

YOU shitty cat.

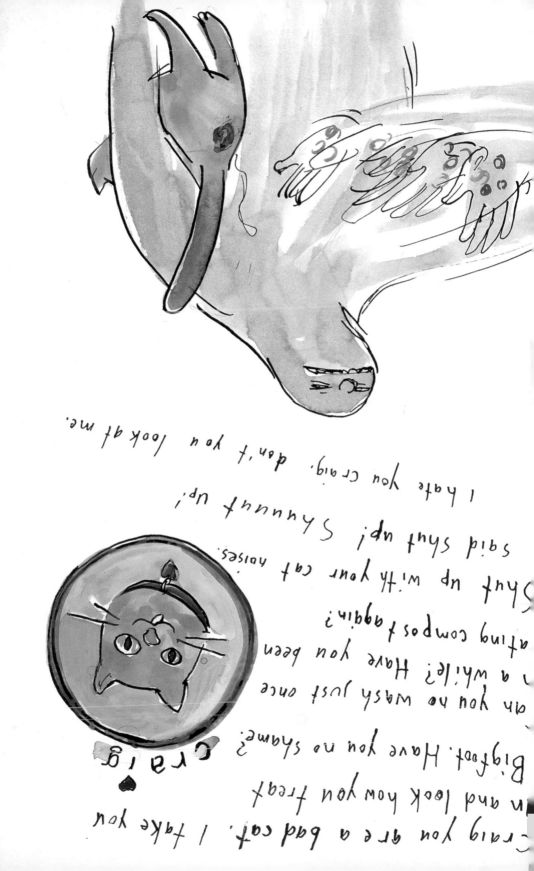

Eat too much

Have gland problem
Mom always say, I handsome and no should
care what other people think. "Big boned"
she say, "Eat more fudge." So me did.
Stranger tell me once "Bigfoot
you sure are fat." After eat
him me start think
maybe he right. Join

Jenny Craig and ~~Jenny Craig~~
freebase on Slimfast.
Member of Rosie's

Chub club. She send

Koosh ball. Like.
 No so fat anymore.

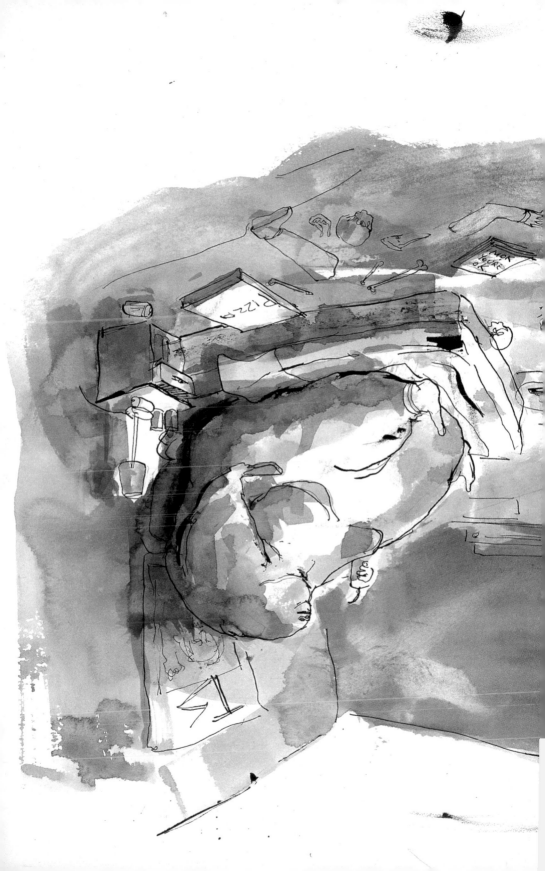

'The Snapperoo'

'The honking hinja'

'Ride the lightning'

JYOU PRIVATE DANCER

'The windy day'

Sugar Pie

The dandy badger

'THE sneaky pete'

CHUGGA CHUGGA
VROOM VROOM
RING
WOOF WOOF

SCREENTEST FOR POLICE ACADEMY

World a stage,
(every exit Entrance)

Example of groundbreaking work from Bonnie and Clyde.

Bigfoot Screen Credits

- Shadowy yokel in woods (Deliverance)
- Shadowy figure in woods (Sling Blade)
- Blurry dark spot behind Fern (Predator)
- Voice of Jar-Jar Binks (Star Wars: Episode one)
- Shadowy figure in woods (You've got Mail)
- Sea lion (Free Willy)
- Production Advisor (Harry and the Hendersons)

Why Denis Why?
Denis.

Miss Denis. He good friend. How me know ramp not stable? Never forgive self, should have double checked trajectory and cross wind variables and adjusted acceleration accordingly. But Denis say "No, Floor it" That just way Denis was. Here for good time, not long time.

So Embarassed

I feel pretty.

AFRAID!

Have dream sometime, I wake up scream.
Marching band chase me through department
store. Some of them on motorcycles, others
crabwalk. Some just walk normal.
They play Muppet theme song over and over
really fast.

That all. Then I wake up scream like I say. It wierd. Now I terrified of marching bands. Feel like I miss out.

Other phobia include: knee high socks, Jack in the boxes, the Irish, dolls, digital watches, bubble bath, canned corn, Irish people.

No could comb over

Hair Go

If you going to chase,
Please no spray with
holy Water.

OK. Listen, I not know where all
you morons come from, but holy water no
hurt Bigfoot. Garlic and Crucifix also no.
Fire, Pitchfork, Silver bullet OK. Cryptonite
do nothing. If not even real. Please stop
sending letters asking. "What you
vulnerability? What Bigfoot?" Like I tell.
What next me bank account number?
Why not you invest time in moving out
of Parent basement? Maybe have sex or
something.

Yes I be talking to you
Steve. Yoooou!

Stalking is a crime Steve.